CHARLES PEARCE

the CALLIGRAPHY sampler

ROMAN ALPHABETS

CHARLES PEARCE

the CALLIGRAPHY sampler

ROMAN ALPHABETS

COLLINS

First published in 1985
by William Collins Sons & Co Ltd
London · Glasgow · Sydney
Auckland · Johannesburg

ISBN 0 00 411909 6

Text set in Sabon
Printed and bound in Spain by
Graficas Reunidas, Madrid

In Memoriam
C.K.R.P. & W.H.M.P.

FOREWORD

Donald Jackson
Scribe to Her Majesty's Crown Office

Even though we do not truly learn from books, but from our own experiences, we can always use a little help!

A good teacher can orchestrate our experiences of life to hasten and reinforce our learning processes. A master can also help us by example to discover the artist in ourselves.

Charles Pearce is a master of the pen, and this sampler is an encouragement to expand your calligraphic repertoire, and thus your ability to express yourself, by analysing and copying the various alphabets and texts he has written out.

Do not be afraid of failure, or indeed of copying too slavishly. Once these processes have become part of your own experience, your *self* will ensure that the letters become your own.

Donald Jackson
1985

INTRODUCTION

The purpose of *The Calligraphy Sampler* is to provide calligraphers with a source of quotations written in different alphabets. Although many teaching manuals exist for the beginner, there are very few sources available to the more experienced calligrapher, other than historical manuscripts. Unfortunately, most of these manuscripts are kept in a small number of collections, mainly in the United States and Europe, and are not readily accessible to the majority of today's practising calligraphers. At the same time, many of the manuscripts that are available are not particularly well written. Another problem facing the student is that most of the early manuscripts were written in a language other than English, and a number of letters in common usage today are not to be found in these earlier examples. The ability to design a letter that fits into the general style of a given alphabet requires considerable study and experience.

On each double-page spread of this book there is an alphabet, with a quotation in that style on the opposite page, to illustrate a sense of the rhythm and interline spacing that each hand requires. Some of the alphabets are straight adaptations of historical hands, and others are more modern styles specifically developed for inclusion here. It will be noted that none of these alphabets has been given a name and the reason for this is quite simple. This is the first book in an intended series of five, which will mean a total of 125 alphabets. The only possible way of naming that number of hands would be to give them names similar to those of typefaces, and I think that would be a rather meaningless exercise.

The art of calligraphy has changed considerably during the last five or six hundred years and that change has been particularly noticeable in the last fifty years or so. In the Middle Ages, the scribe was employed solely as a communicator. He had to write out page after page of text with little opportunity to display his more flamboyant skills (assuming that he had any). It was, on the face of it, a rather tedious existence. However, with the introduction of moveable type in the fifteenth century, the calligrapher was no longer needed to write out long screeds, and the era of the writing master dawned. These men pro-

duced their writing manuals, full of flourishes and over-elaboration, to show off their talents.

Following the virtual death of calligraphy in the late seventeenth century and its subsequent rebirth at the beginning of the twentieth century, the modern scribe has had to become a fully fledged interpretive and decorative artist. While today's calligrapher should have the ability to write text hands at least as well as his mediaeval predecessors, he must also be able to create pages of great visual impact that will hold up against the work of present day painters and graphic designers. To be sure, the calligrapher is one of a strange breed. What person in his right mind would devote his life to the design and execution of twenty-six pre-ordained shapes, which must be changed and adapted at will to suit the sense of a written piece? For far too long calligraphers have fallen between the two stools of Craft and Art, but a determined effort is now being made to achieve recognition by the art establishment.

Apart from the overall approaches to design, great changes have taken place in writing in recent years. Edward Johnston, the first modern scribe to realise that the alphabets in historical manuscripts had been executed with a broad-edged pen, always maintained that the angle of the pen should remain constant. While this is an important starting point for the beginner, so that he may understand how the thick and thin strokes are achieved, it is no longer true in the hands of the more advanced practitioners of the art. Indeed, if one looks at the work of Johnston himself, it is obvious that the pen angle did not remain constant. The lack of consistency in pen angle, both in Johnston's work and in that of the mediaeval scribes, was almost certainly a subconscious effect of the freely written letter. These days, however, we are much more conscious of that changing angle and the variety of new possibilities it affords.

Historically speaking, the word 'Roman' was a rather narrow term, referring to the formal hands and monumental capital letters of ancient Rome. The two formal hands were Quadrata (Roman Square Capitals) and Rustica (Rustic Capitals), and the monumental letters were those carved into stone, such as appear on the Trajan column. (There is some doubt as to whether the Quadrata was a true Roman hand or just a strange quirk of fate. There are now only two Quadrata manuscripts in existence and they

are both thought to have been written in the same place. It has been suggested that, as they were executed at about the same time, they could have been written by the same man, and thus are not representative of a style of that era.) 'Roman' has now come to mean any style that is upright and rounded with which capital letters similar to those on the Trajan column can be used. In typography, it is any letter with a serif, which is round, upright and suitable for use as a text face. For the purpose of this book, therefore, 'Roman' will be used in its widest possible sense.

The earliest of the Roman hands (using this broad definition) with both majuscule and minuscule (upper and lower case) letters was the Carolingian hand of the late eighth century. After Charlemagne's rise to power, he was aware of the vast array of different styles of writing being used within the Holy Roman Empire at that time, many of which were all but illegible, and certainly unattractive. In 789 AD he ordered Alcuin of York to organize a number of scribes to design a standard writing hand to be used throughout his empire. Alcuin's team took as their basis a hand that was in use at the monastery of St Martin at Tours. The Carolingian hand which they arrived at was an attractive, freely-written, rather squat letter, which, with its wide interline spacing, made it extremely easy to read. This hand continued in use for some two hundred years, outlasting Charlemagne and even his Holy Roman Empire, and is generally considered to have reached its apogee in the tenth century Winchester Hand. This English hand, perhaps best demonstrated in the Ramsey Psalter (*Harley 2904, British Museum*), is a slightly more formal version than the original, having more consciously constructed serifs than the looped ends so characteristic of early Carolingian. It was on this hand that Edward Johnston based his Foundational Hand, still considered by many teachers to be the best learning hand.

With the sweep across Europe of Gothicism, the rounded legible letters of the Caroline era gave way to the pointed arch of the Black Letter (Textus Quadratus). The upsurge of interest in learning during the twelfth and thirteenth centuries which had followed the increase in international trade, meant a greater demand for books. These books had to be produced more cheaply because they were no longer

just wanted by the wealthy. The Gothic Black Letter with its very tight texture, allowed many more words on the page and thus far fewer pages, making for cheaper books. Throughout this scholarly and artistic revolution, there were one or two pockets of Europe that kept to a more rounded style of letter. These areas tended to be mainly in the south, and especially in the City States which make up modern day Italy. The Rotunda Hand of southern Europe, though definitely Gothic influenced, managed to retain a certain roundness and softness which made it more legible than its harsher northern counterparts.

The late fourteenth and fifteenth centuries saw two very important happenings for mankind. The first was the birth of the Italian Renaissance, and the second was the invention of moveable type. The beginning of the Renaissance saw scholars, artists and architects looking back to the classical learning and design of ancient Greece and Rome. Painting and sculpture became much more realistic with the increased awareness and understanding of anatomy and perspective; architects began to comprehend the subtleties of Greco-Roman building design which they incorporated into their own architectural styles.

With all this attraction to classical form and outlook it was inevitable that a writing style would develop which reflected this new order. The first alphabet which could truly be said to be a product of the Renaissance was the 'lettera humanistica'. Poggio Bracciolini (generally known as Poggio), a scribe and scholar from Arezzo, spent much time travelling Europe in an attempt to find worthy manuscripts and writing styles on which to base a true classical hand. His search took him as far as England, where, although he was only able to find one manuscript, he was more than likely influenced by the tenth century Winchester Hand in his development of the first true Roman hand. His 'lettera humanistica' dates from the early 1400s and can be called the heart of the modern Roman minuscule or lower case alphabet.

The invention of moveable type in the middle of the fifteenth century precipitated the rapid demise of the scribe as a communicator. A few scribes were needed by the printers to insert initial letters in a second or third colour, but this was scarcely enough work for more than one in a hundred of their number. Although the early printed works were set exclusively in Gothic type (viz. the Gutenberg Bible)

it was not long before the reforms of the Renaissance made themselves felt in the printing industry. The city of Venice was the site of the first attempts to design a Roman type. Johann and Wendelin, two brothers from Speyer in Germany, were among the first to try to put Italian calligraphy into type. They used as their model the 'lettera humanistica' which had been developed some sixty five years earlier. While their typefaces were very beautiful, it was a Frenchman, also working in Venice, named Nicholas Jenson, whom William Morris considered to have produced the Roman type which most nearly achieved perfection.

Unfortunately, as printing became well and truly launched in the fifteenth century, calligraphy began to founder. The sixteenth century saw the rise and eventual fall of the writing master. Such men as Arrighi, Tagliente, and Palatino possessed wonderful writing skills, but because there was little call for those skills beyond teaching, they were barren. Type having taken over from calligraphy as the graphic communicator, the only handwriting required was for the writing of letters or taking of notes. The change from printing by wood block (relief process) to printing from an engraved metal plate (intaglio) to produce the writing masters' copybooks led to a further decline in calligraphic standards. Now the engraver, who knew little or nothing about the making of good letters, began to influence the penman. It became necessary for the penman to use a flexible pointed pen so that the thick and thin strokes could be achieved by pressure rather than the shape of the pen. The engraver's burin works in the same way: the greater the pressure, the heavier the stroke. And so, the broad-edged pen was lost until its importance was rediscovered at the beginning of the twentieth century by Edward Johnston.

During this period of decline for calligraphy, typography and type design went from strength to strength with such men as Aldus Manutius, Griffo, Caxton, Bodoni and Didot, as well as a host of others, all designing successful typefaces. The Roman typeface has numerous variations and is still the only true book text face. Some books have been set in sans serif faces but they tend to be difficult to read. The serif forces the eye to move along the line of type or writing until it reaches the end and then allows it to drop down to the next line. The sans serif letter,

however, useful though it may be for other applications, does not work in a book; the eye has a tendency to wander off the line, which then has a similar effect on the mind. To this day, the most successful type designer is the one who is able to design a good, distinctive Roman type face.

That ability to be able to design a good text hand is equally as important for the calligrapher as for the type designer. However, unlike the type designer, the calligrapher must concern himself with more than just letterform. He must also consider the rhythm and spontaneity of his writing. Rhythm in calligraphy is very similar to that of music. It will vary with the piece and the style of writing being used. A Gothic Black Letter, for instance, generally has the same distance between vertical strokes as the width of each individual stroke. To keep that rhythm even, the space between the letters (the interspace) will be about the same as the space inside the letter (the counter). With a Roman hand the principle is exactly the same, but the execution is different. Because the counter of a Roman letter is very open, so the interspace must be correspondingly larger than the Gothic Black Letter. This principle holds true with capital letters, too. There is also an additional rule to be aware of. In three groups of letters a lot of interspace occurs: LA, TT, and TV. When these letters occur together in those arrangements, the bars of the letters may be shortened to reduce the space a little, but the remaining area between the letters will govern the spacing of all the rest of the letters in that piece of writing.

Much has been said and written on the subject of freedom and spontaneity in calligraphy and, while they are qualities much to be admired, they can be extremely dangerous if not treated with caution. Too many times shabby letterforms have been concealed behind the cloak of freedom. Executing a page of writing with weak letterforms is like building a house with unbaked bricks. It may have been designed with great freedom, flair and spirit, but it will not stand up for long. We must all aim for strength and beauty in our letters which are, after all, the basic building blocks of calligraphy. Once having understood the design and form of a given letter shape, then write it freely, spontaneously and lovingly.

New York, September 1984

Dictators
ride to and fro upon tigers
which they dare not dismount.
And the tigers are getting
hungry.

WINSTON CHURCHILL · *while England slept*

abc defghij klm nopqrstu vwxyz

ABCDEF
GHIJKLM
NOPQRS
TUVWXYZ

COGITO
ERGO
SUM

I think,
therefore I am.

RENE DESCARTES · *Le Discours de la Méthode*

there are two things
which I am confident I can do very well:
 one is an introduction to any literary work stating what it is to contain
and how it should be executed in the most perfect manner;
the other is a conclusion, showing from
 various causes why the execution
has not been equal to what the
 author promised to himself
and to the public.

abcdefgh
ijklmnopq
rsʃttuvwxyz

abcdefghijkl
mnop qrstuv
wxyz

ANONYMOUS · Pakistani delegate at International Planned Parenthood Conference

d the best
contraceptive
is a glass of cold water:
not before or after,
but instead

If music be the food of love, play on;
Give me excess of it, that surfeiting,
The appetite may sicken, and so die.
That strain again! it had a dying fall:
O! it came o'er my ear like the sweet sound
That breathes upon a bank of violets,
Stealing and giving odour! Enough! no more:
'Tis not so sweet as it was before.
O! spirit of love! how quick and fresh art thou,
That notwithstanding thy capacity
Receiveth as the sea, nought enters there,
Of what validity and pitch soe'er,
But falls into abatement and low price,
Even in a minute: so full of shapes is fancy,
That it alone is high fantastical.

WILLIAM SHAKESPEARE
Twelfth Night. Act I, Scene i

abcd
efghijkl
mnop
qrstuvw
xyz

ABCDEF
GHIJKLMNO
PQRST
UVWXYZ

F

ABRAHAM LINCOLN · *Annual Message to Congress, 1 December 1862*

IN GIVING
FREEDOM TO THE SLAVE,
WE ASSURE
FREEDOM TO THE FREE—
HONOURABLE ALIKE
IN WHAT WE GIVE
AND WHAT WE PRESERVE·

da mihi
castitatem
et continentiam
give me chastity and continence sed
but do not give it yet
noli modo

ST·AUGUSTINE · *Confessions. Book VIII, chap.vii*

abc
de
fghijklmnopq
rst
uvwxyz

abcdɛfghyklm
nopq rſstuv
wxyz

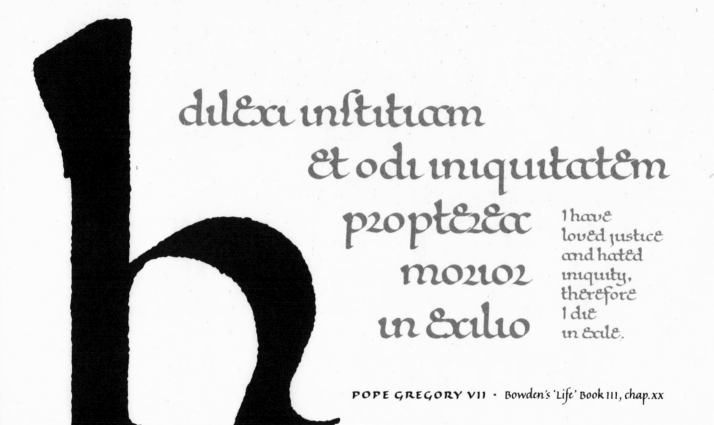

h dilexi institiam
et odi iniquitatem
propterea · I have
loved justice
morior and hated
iniquity,
in exilio therefore
I die
in exile.

POPE GREGORY VII · Bowden's 'Life' Book III, chap.xx

Life is made up of sobs,
sniffles and smiles, with
sniffles predominating.

O · HENRY (W · S · PORTER) · *Gifts of the Magi*

abcdef
ghij
klm
nopqrstuv
wxyz

ABCDE
FGHIJKLM
NOPQR
STUVWXYZ

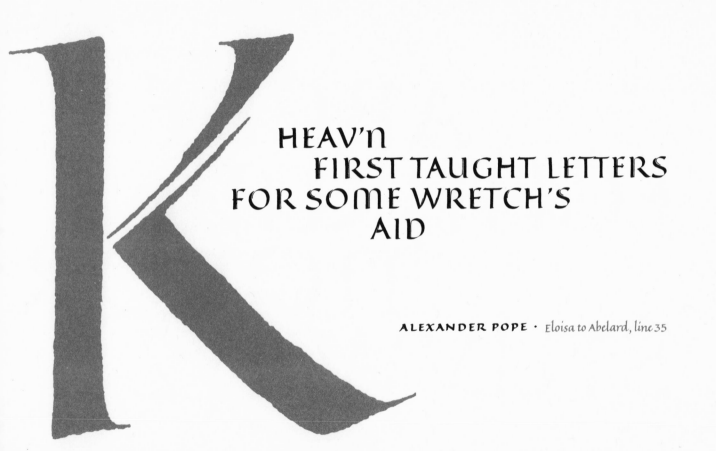

HEAV'n
FIRST TAUGHT LETTERS
FOR SOME WRETCH'S
AID

ALEXANDER POPE · *Eloisa to Abelard, line 35*

SIC TRANSIT GLORIA MUNDI

O HOW QUICKLY DOTH THE GLORY OF THE WORLD PASS AWAY

THOMAS A KEMPIS · *Imitatio Christi. trans. Anthony Hoskins*

ABCD
EFGHIJKLM
NOPQRST
UVWXYZ

abcd
efg
hijklmnopq
rstuv
wxyz

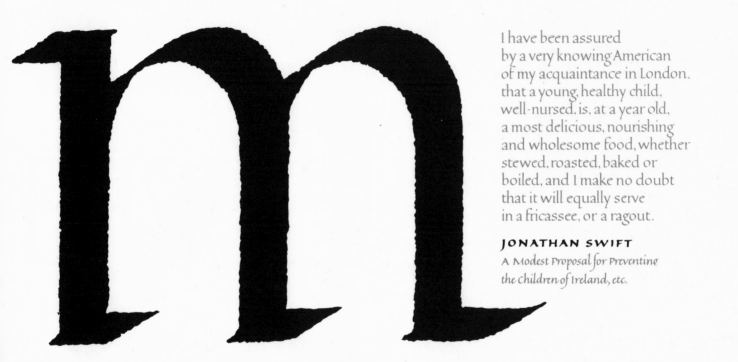

I have been assured
by a very knowing American
of my acquaintance in London,
that a young, healthy child,
well-nursed, is, at a year old,
a most delicious, nourishing
and wholesome food, whether
stewed, roasted, baked or
boiled, and I make no doubt
that it will equally serve
in a fricassee, or a ragout.

JONATHAN SWIFT
*A Modest Proposal for Preventing
the children of Ireland, etc.*

GEORGE BERNARD SHAW
Maxims for Revolutionists

EVERY·MAN·OVER·FORTY·IS
A·SCOUNDREL

ABCD
EFGHIJKLMNO
PQRSTU
VWXYZ

abcd

efghijkl

mnopqr

stuv

wxyz

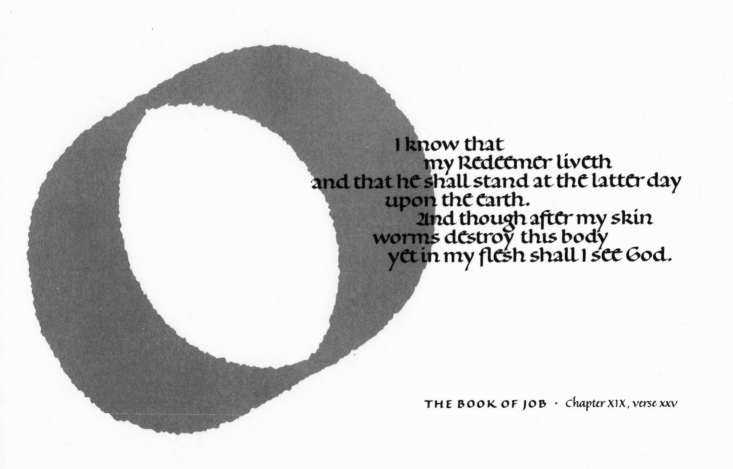

I know that
my Redeemer liveth
and that he shall stand at the latter day
upon the earth.
And though after my skin
worms destroy this body
yet in my flesh shall I see God.

THE BOOK OF JOB · *Chapter XIX, verse xxv*

A democracy,
 that is, a government
of all the people, by all the people,
 for all the people;
of course, a government after the
 principles of eternal justice,
 the unchanging laws of God;
for shortness' sake,
 I will call it the idea of
 freedom.

THEODORE PARKER
The American Idea. Speech at Boston, 29 May 1850

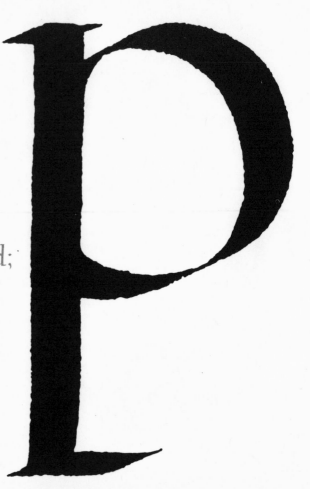

abc defghijkl
mnop qrstuvw
xyz

ABCD
EFGHIJKLMN
OPQRSTU
VWXYZ

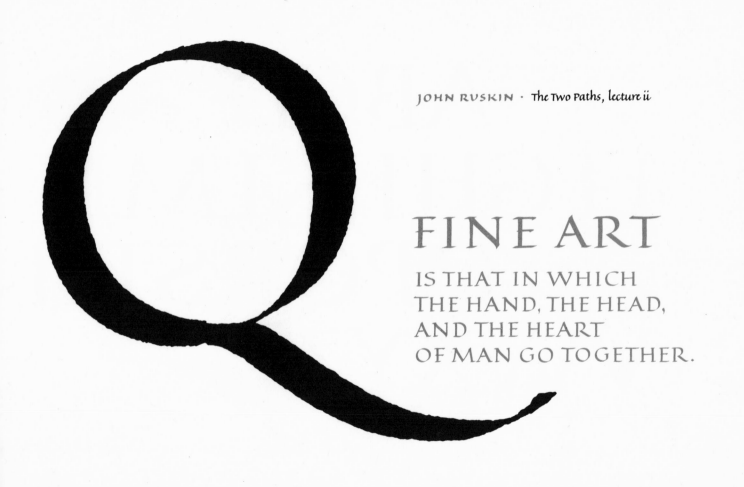

JOHN RUSKIN · The Two Paths, lecture ii

FINE ART

IS THAT IN WHICH
THE HAND, THE HEAD,
AND THE HEART
OF MAN GO TOGETHER.

We hold
these truths
to be self evident,
that all men are created equal,
that they are endowed
by their Creator
with certain unalienable rights,
that among these
are life, liberty,
and the pursuit of happiness.

abc

defg

hijkl

mnopqrſs

ttuvwxyz

ABCDEFGH
IJKLMNOPQRST
UVWXYZ

VOX·POPVLI
VOX·DEI

THE·VOICE·OF·THE·PEOPLE
IS·THE·VOICE·OF·GOD

ALCVIN OF YORK · *Letter to Charlemagne*

J·R·ACKERLEY · *Hindoo Holiday*

There was so much sculpture
that I should certainly have
missed the indecencies if Major
Pomby had not been considerate
enough to mention them.

abc
defghijkl
mnop
qrstuvw
xyz

ABCDEFG
HIJKLMNOP
QRSTUVW
XYZ

OSCAR WILDE · *Picture of Dorian Gray, Chapter 2*

THE ONLY WAY
TO GET RID OF
TEMPTATION
IS TO
YIELD TO IT

everybody talks of the constitution,
but all sides forget
that the constitution is extremely well,
and would do very well,
if they would but let it alone.

HORACE WALPOLE · Letter to Sir Horace Mann, 18 January 1770

abcdef
ghyklmnop
q2rsftuvw
xyz

abcdef
ghïj
klmno
pqrstuvw
xyz

W

We, the English,
seem, as it were,
to have conquered and peopled
half the world
in a fit of absence of mind.

SIR JOHN SEELEY · The Expansion of England.

THE TREE OF LIBERTY
MUST BE REFRESHED
FROM TIME TO TIME
WITH THE BLOOD OF
PATRIOTS AND TYRANTS.
IT IS ITS NATURAL MANURE.

THOMAS JEFFERSON
Letter to W·S·Smith, 13 November 1787

ABCDEFGH
IJKLMNOP
QRSTUVW
XYZ

abcdefghijklmnopqrstuvwxyz

Y

I maintain that though you would often in the fifteenth century have heard the snobbish Roman say, in a would-be off-hand tone, 'I am dining with the Borgias tonight,' no Roman ever was able to say, 'I dined last night with the Borgias'.

SIR MAX BEERBOHM · *Hosts and Guests*

ANONYMOUS

DANCING IS A
PERPENDICULAR EXPRESSION
OF A
HORIZONTAL DESIRE

ABCDEFG
HIJKLM
NOPQRSTUV
WXYZ